Girly Doodles Coloring book

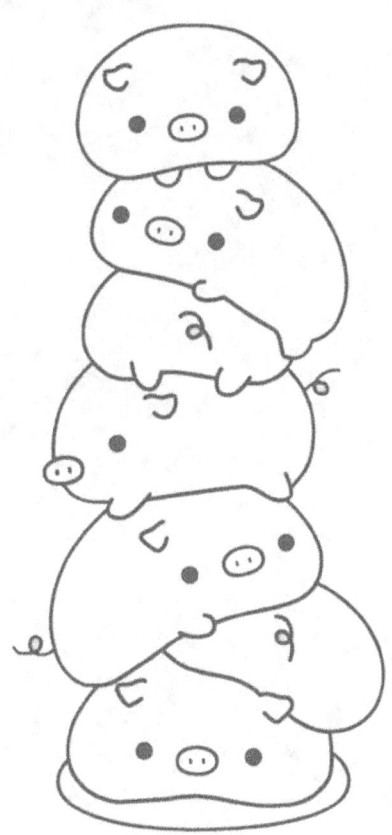

By Nina Packer

Girly Doodles Coloring book

Copyright: Published in the United States by *Nina Ppacker*

All rights reserved. No part of this publication may be reproduced, stored in retrieval system, copied in any form or by any means, electronic, mechanical, photocopying, recording or otherwise transmitted without written permission from the publisher. Please do not participate in or encourage piracy of this material in any way. You must not circulate this book in any format Nina Packer *does not control or direct users' actions and is not responsible for the information or content shared, harm and/or actions of the book readers.*

ISBN: 9781791598181

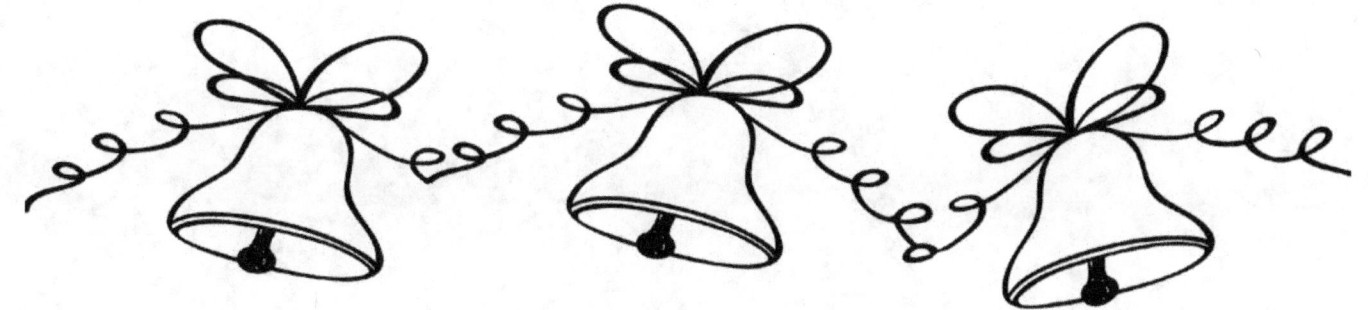

This Book Belong to

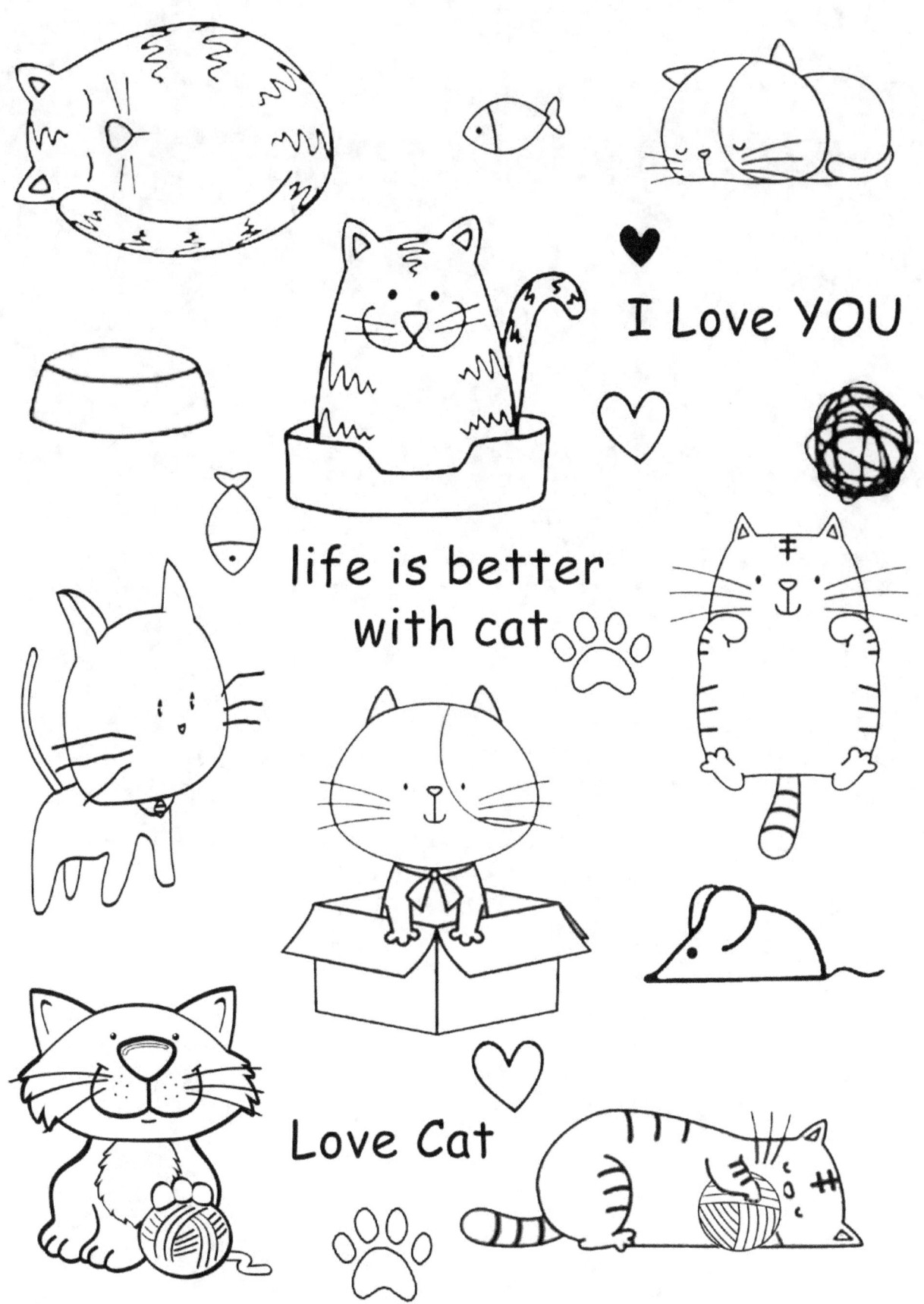

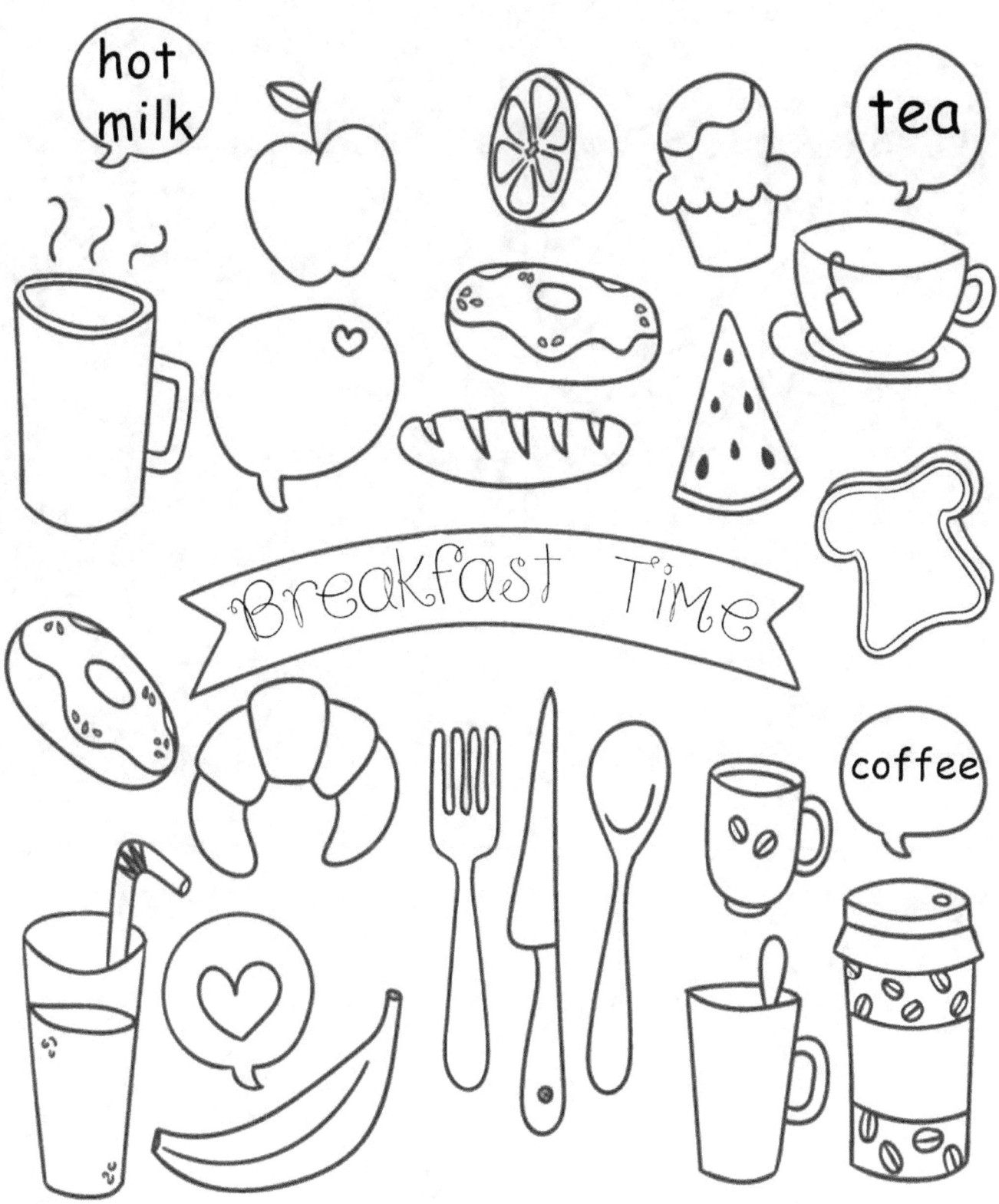

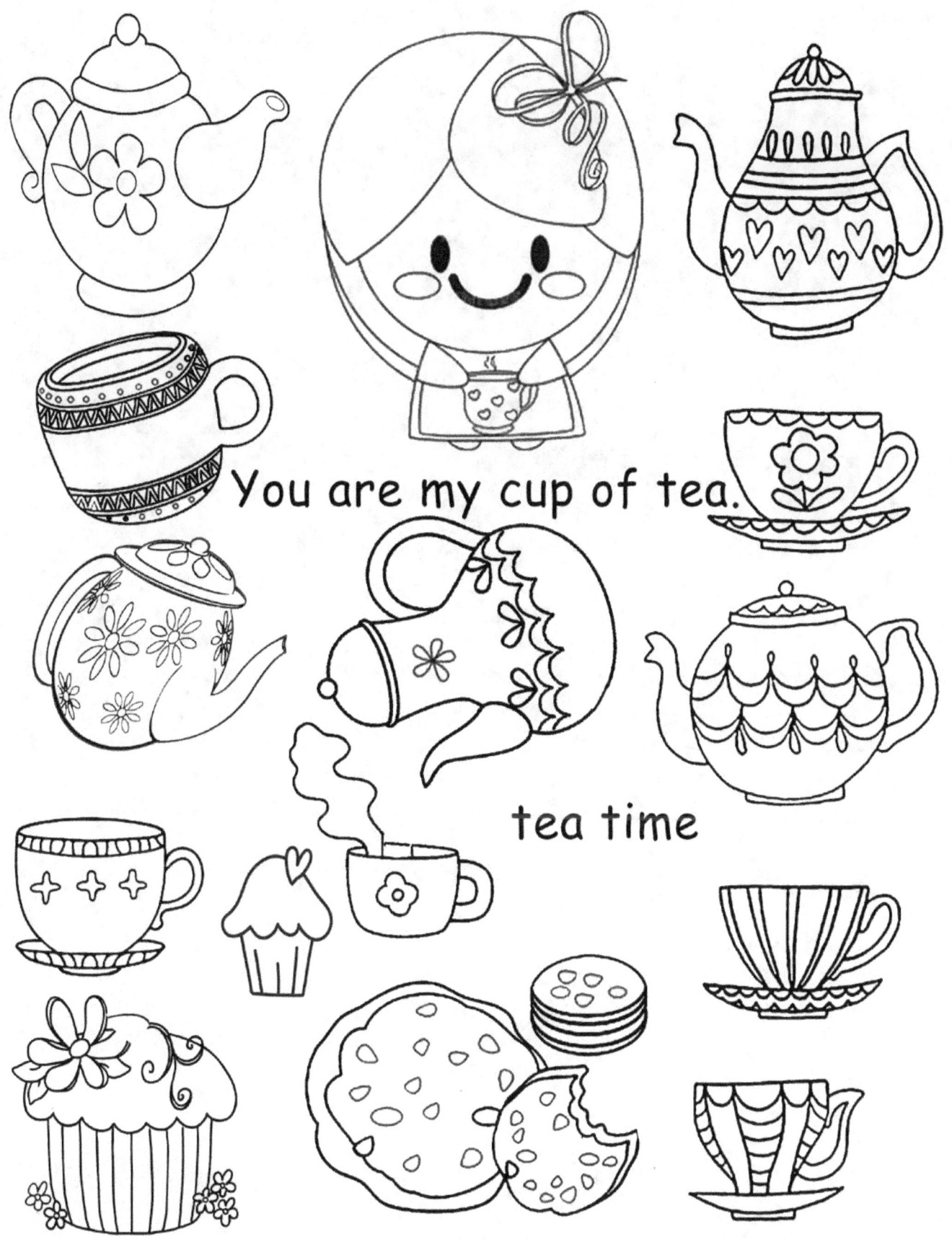

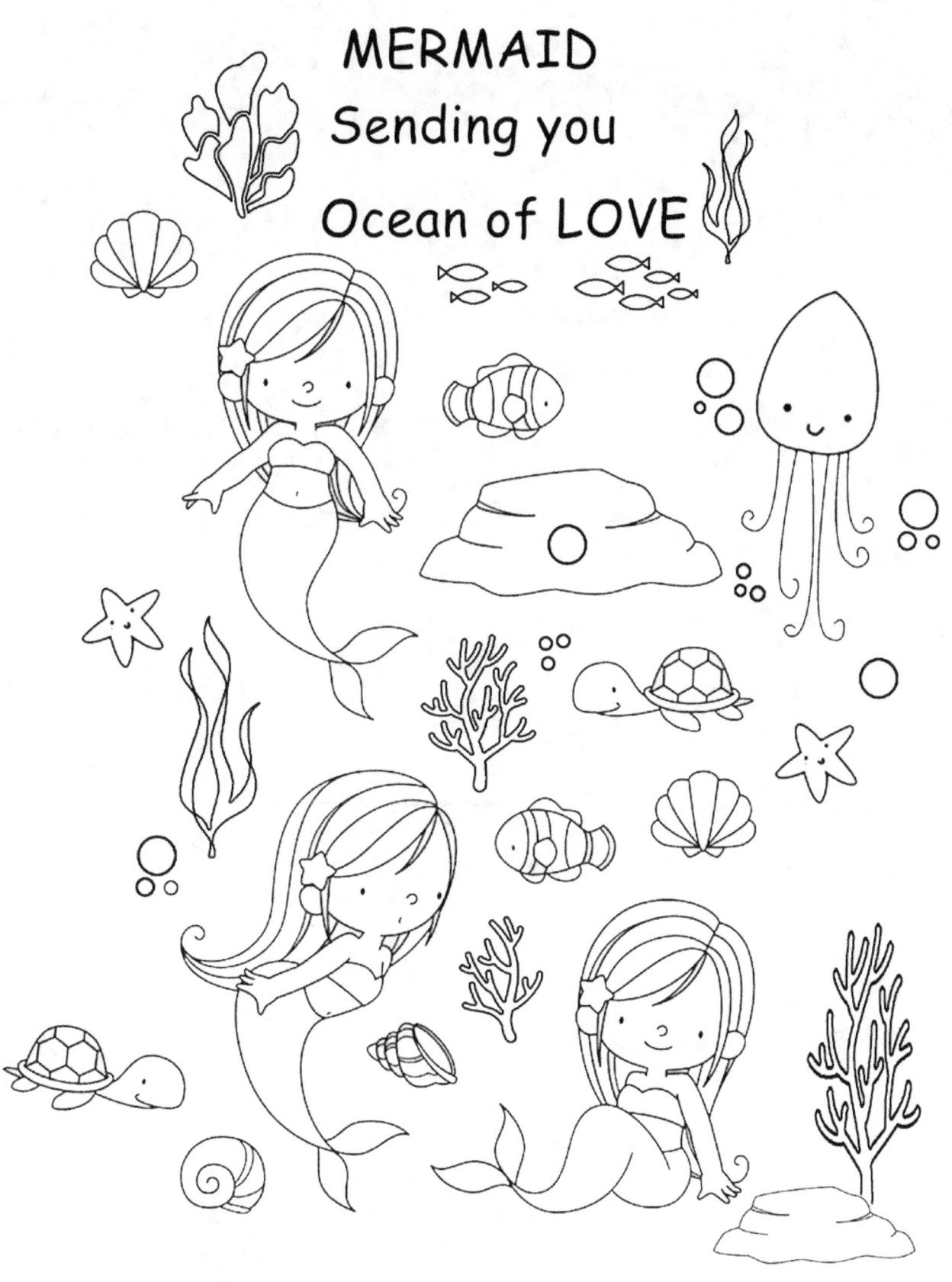

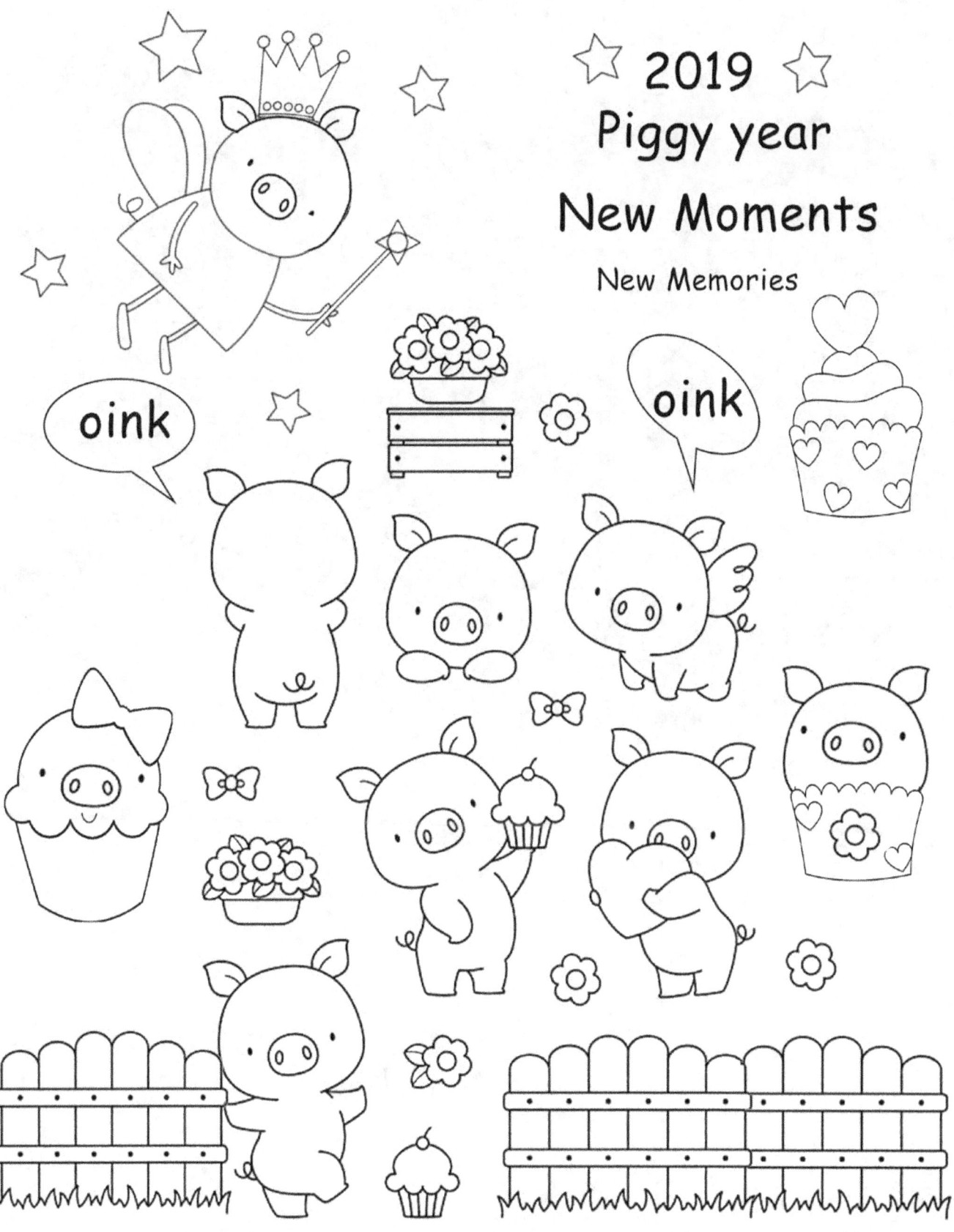

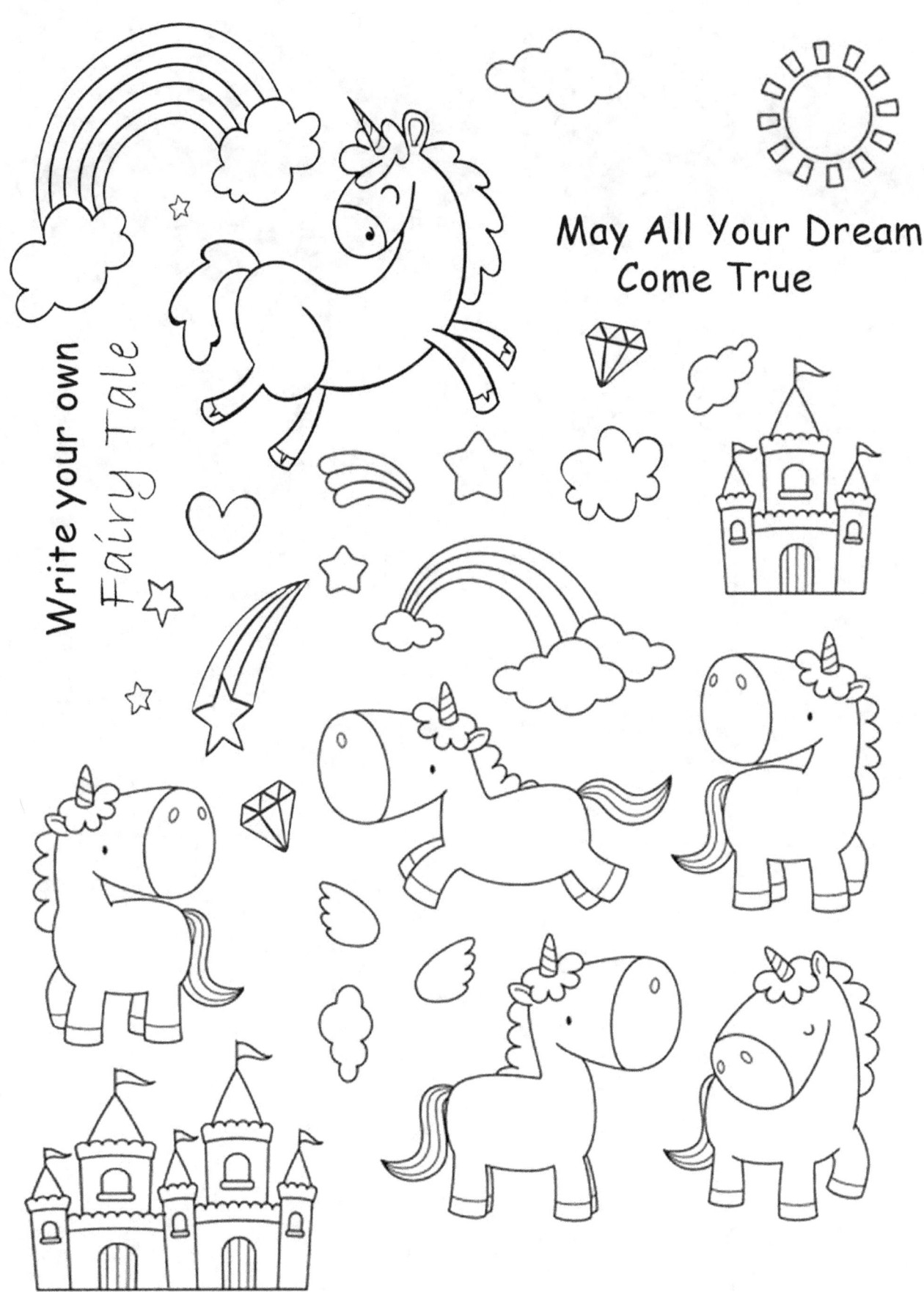

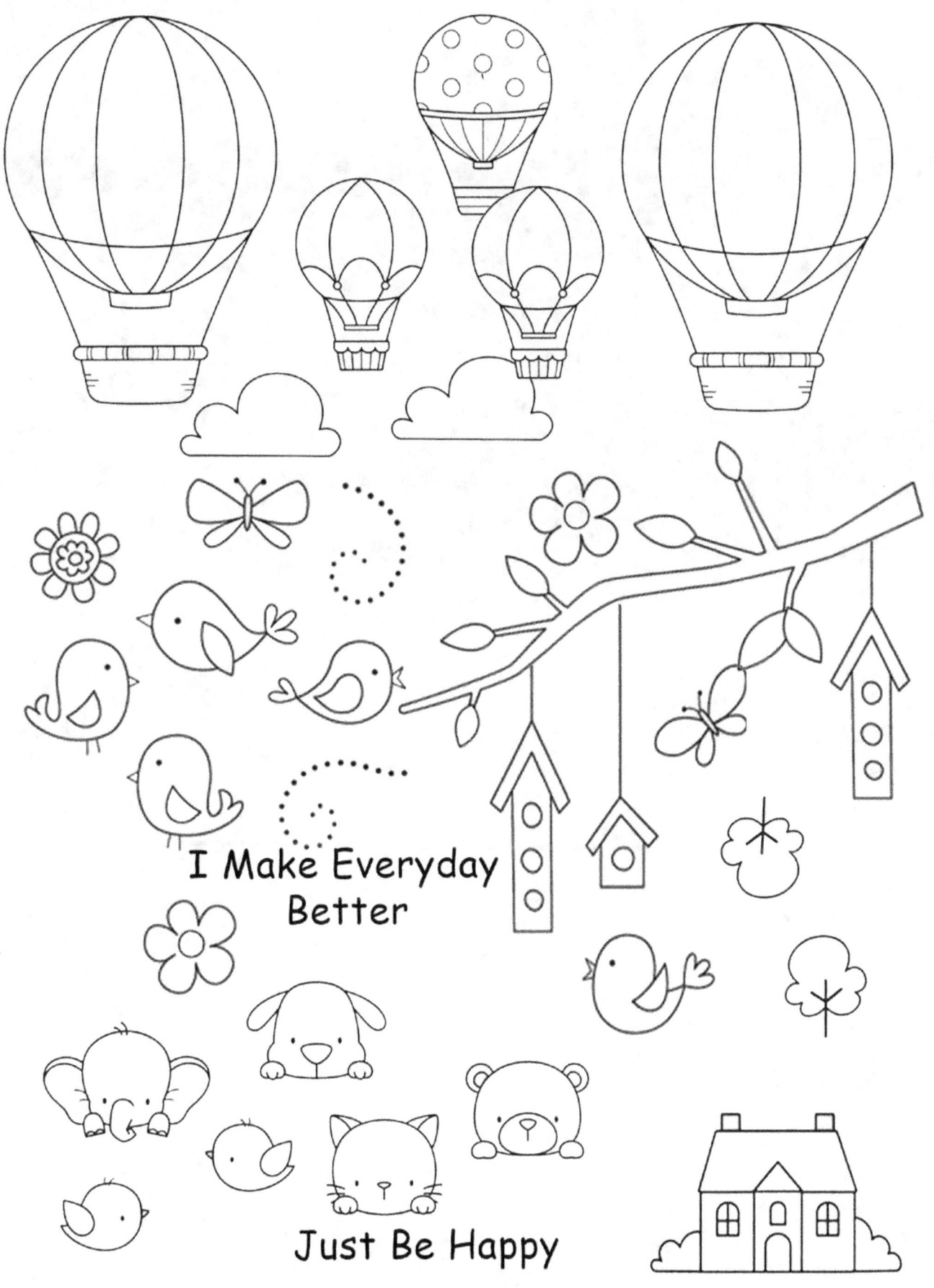

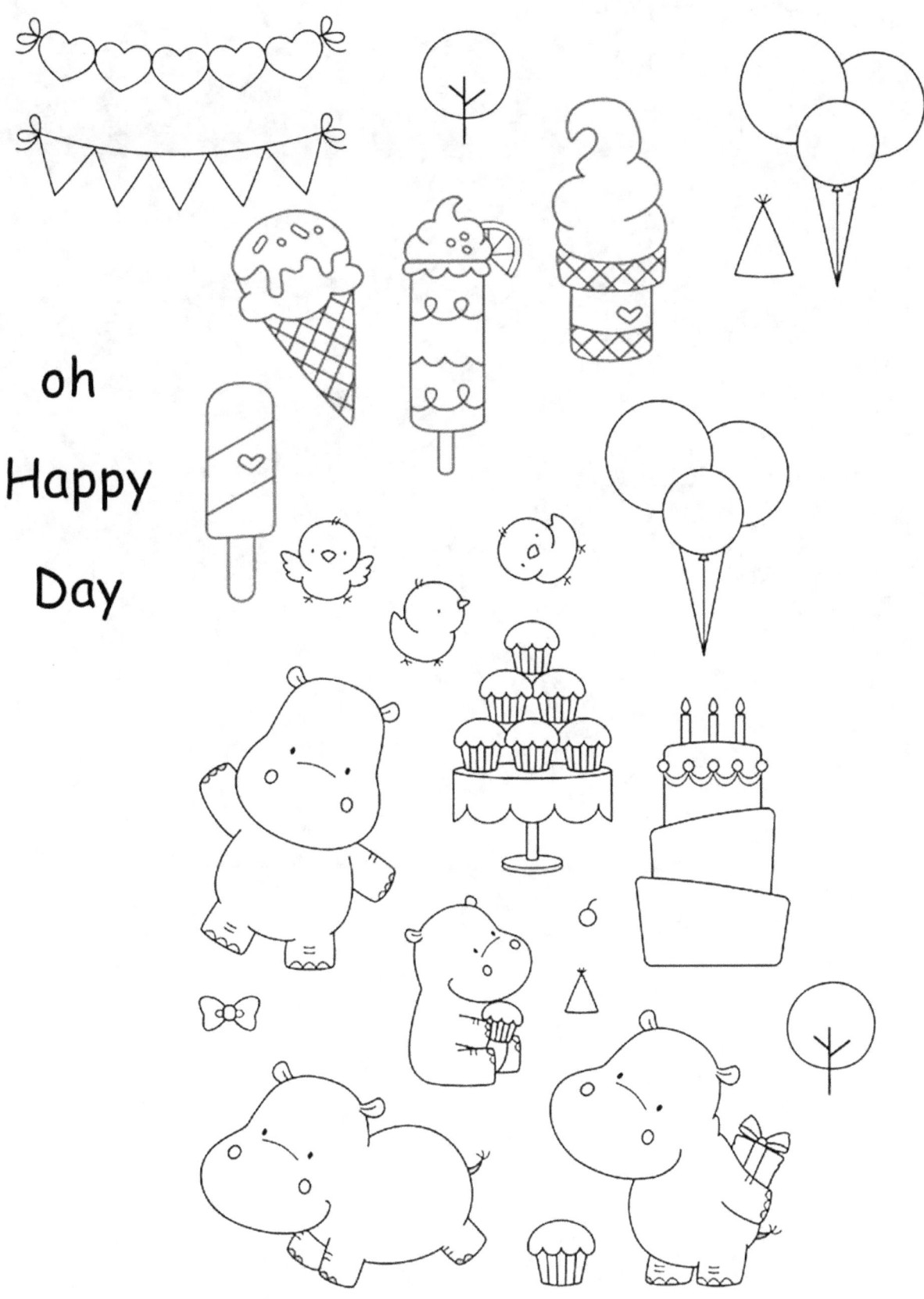

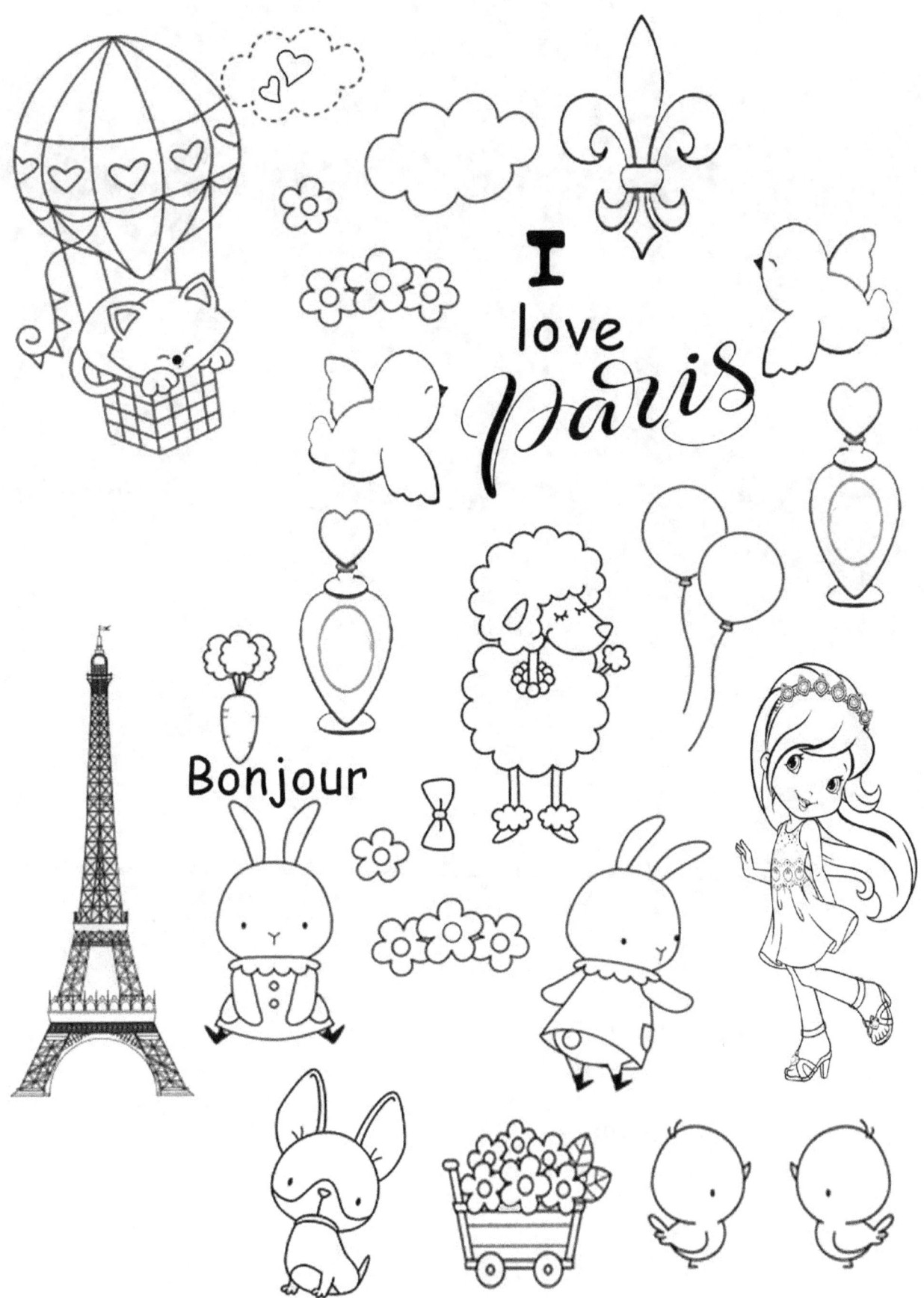

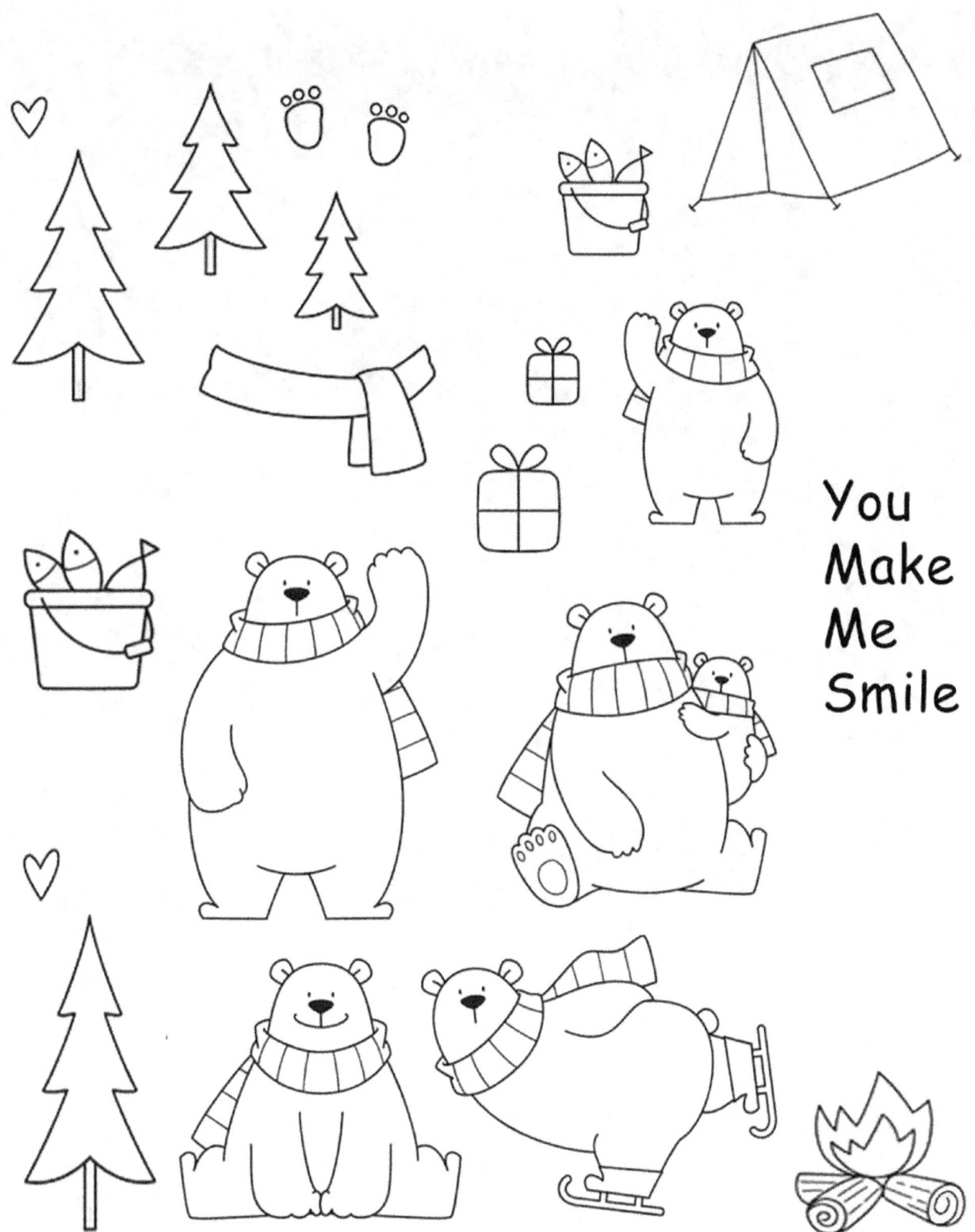

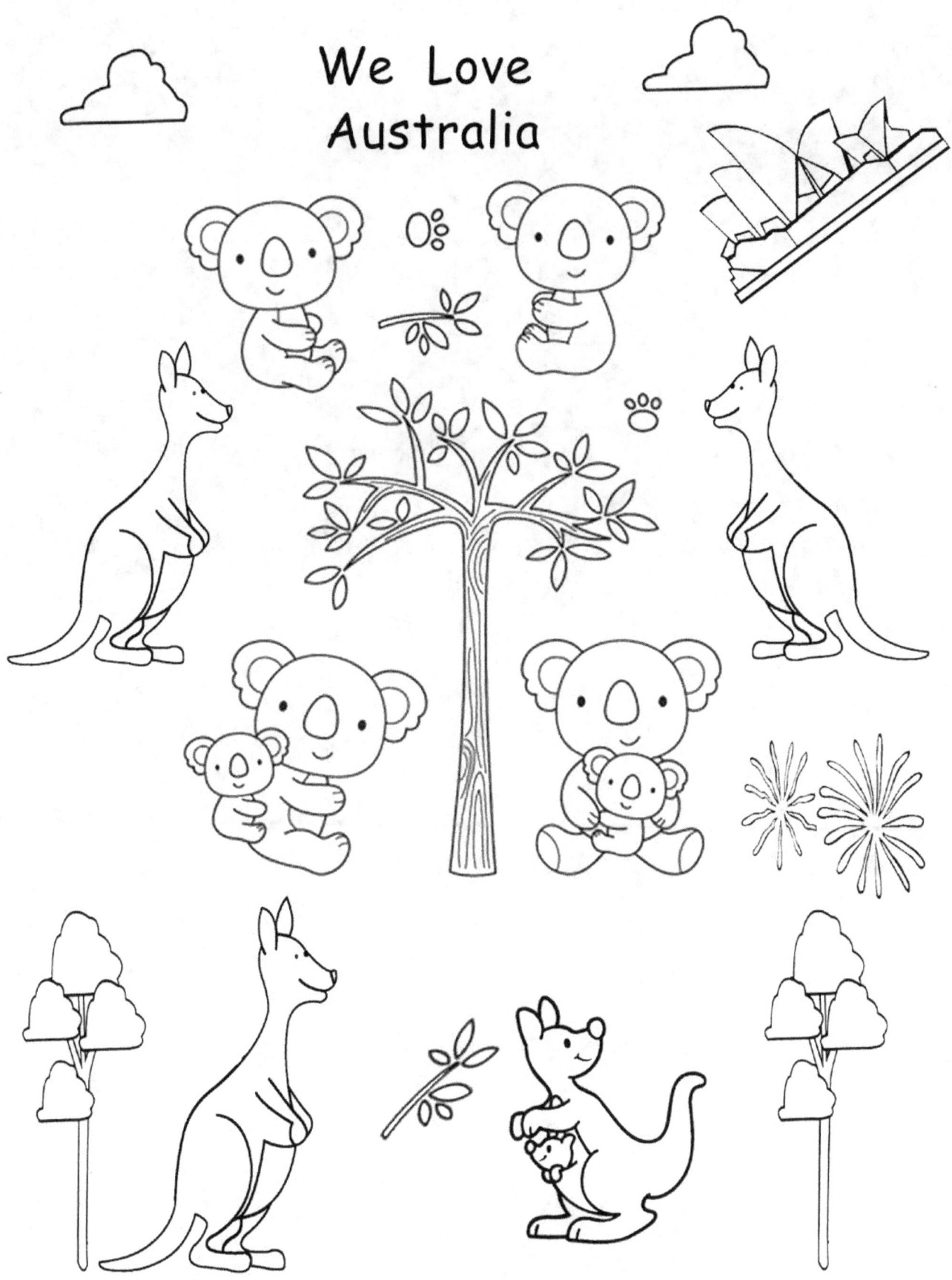

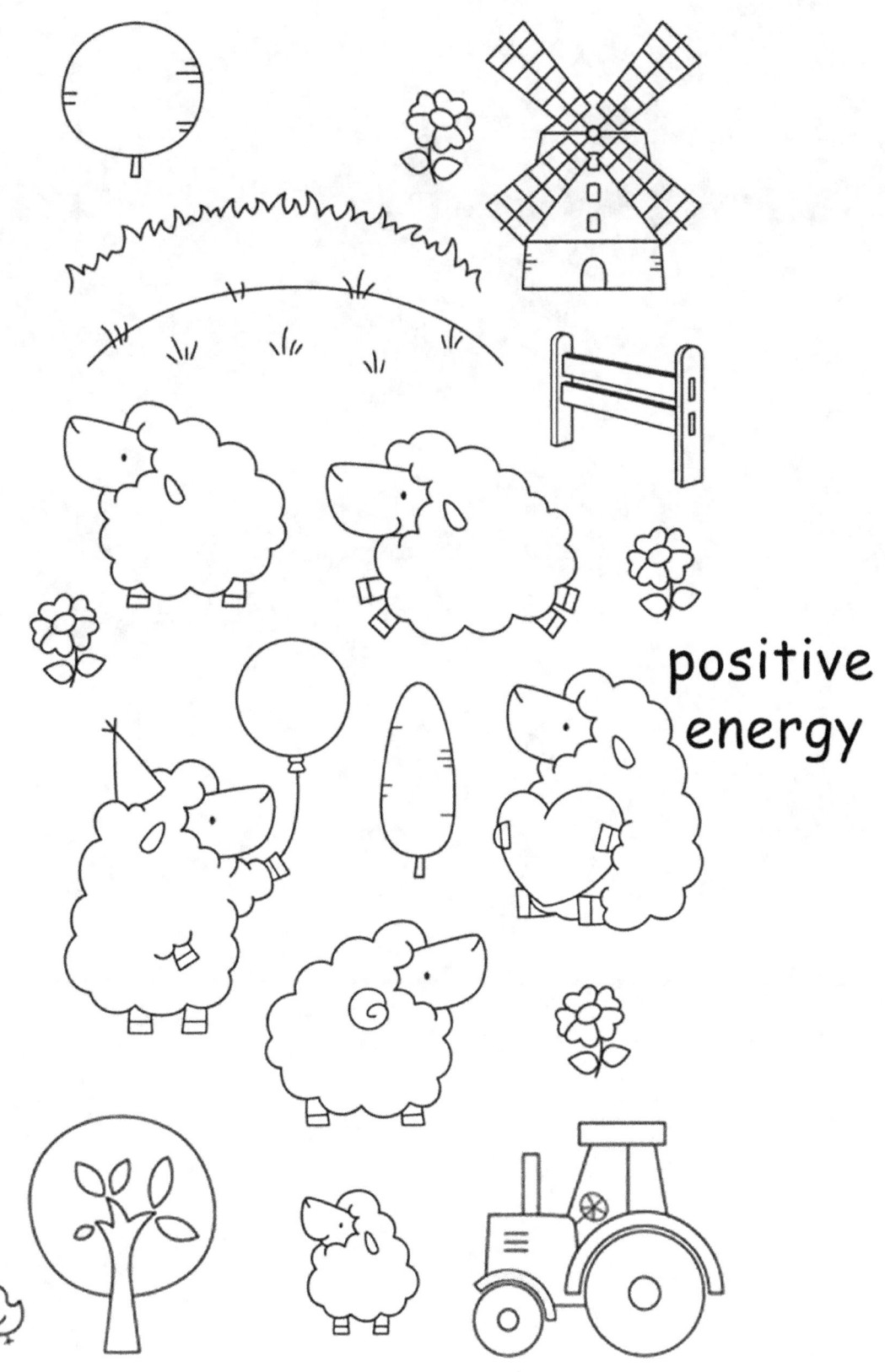

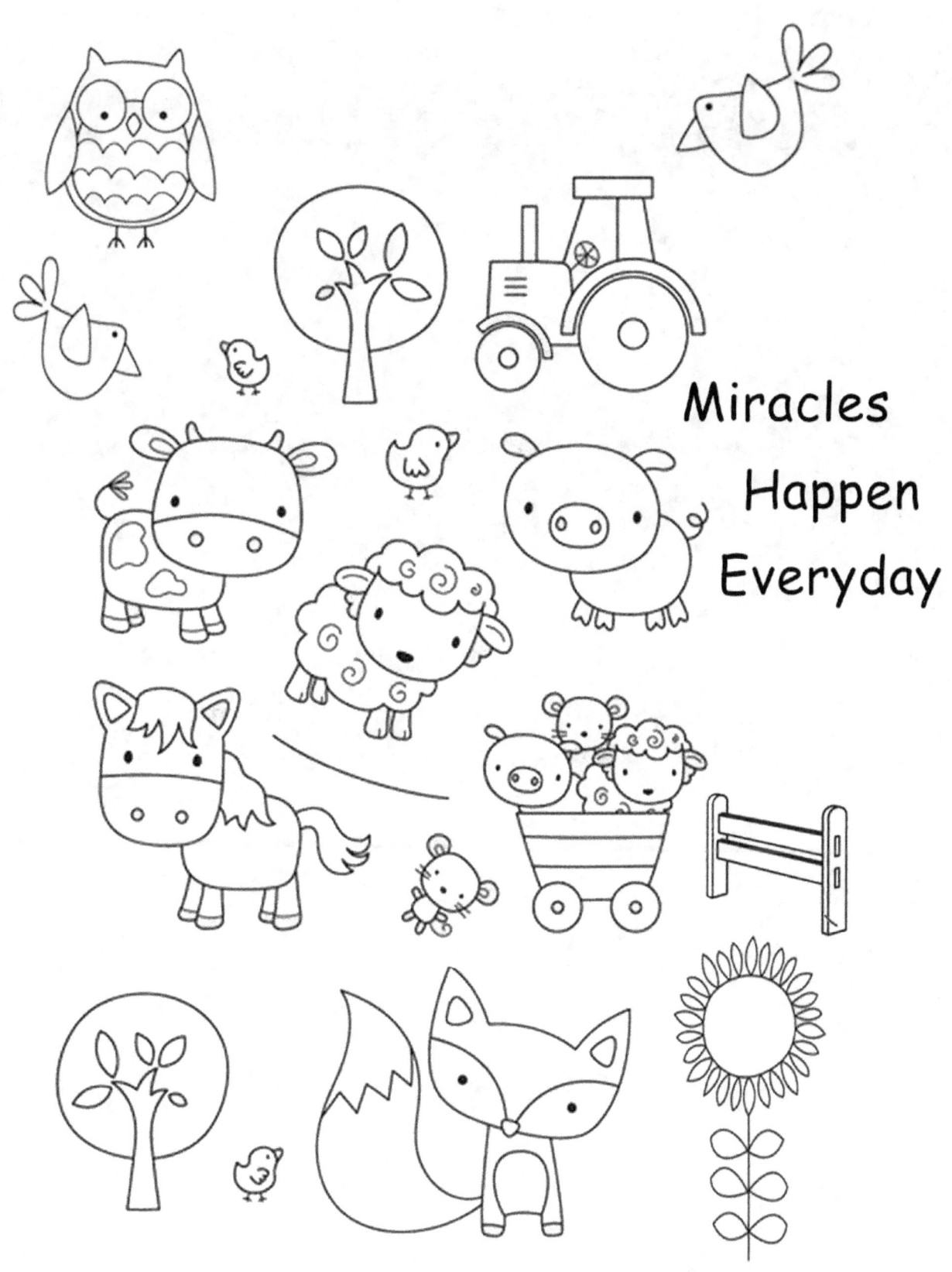

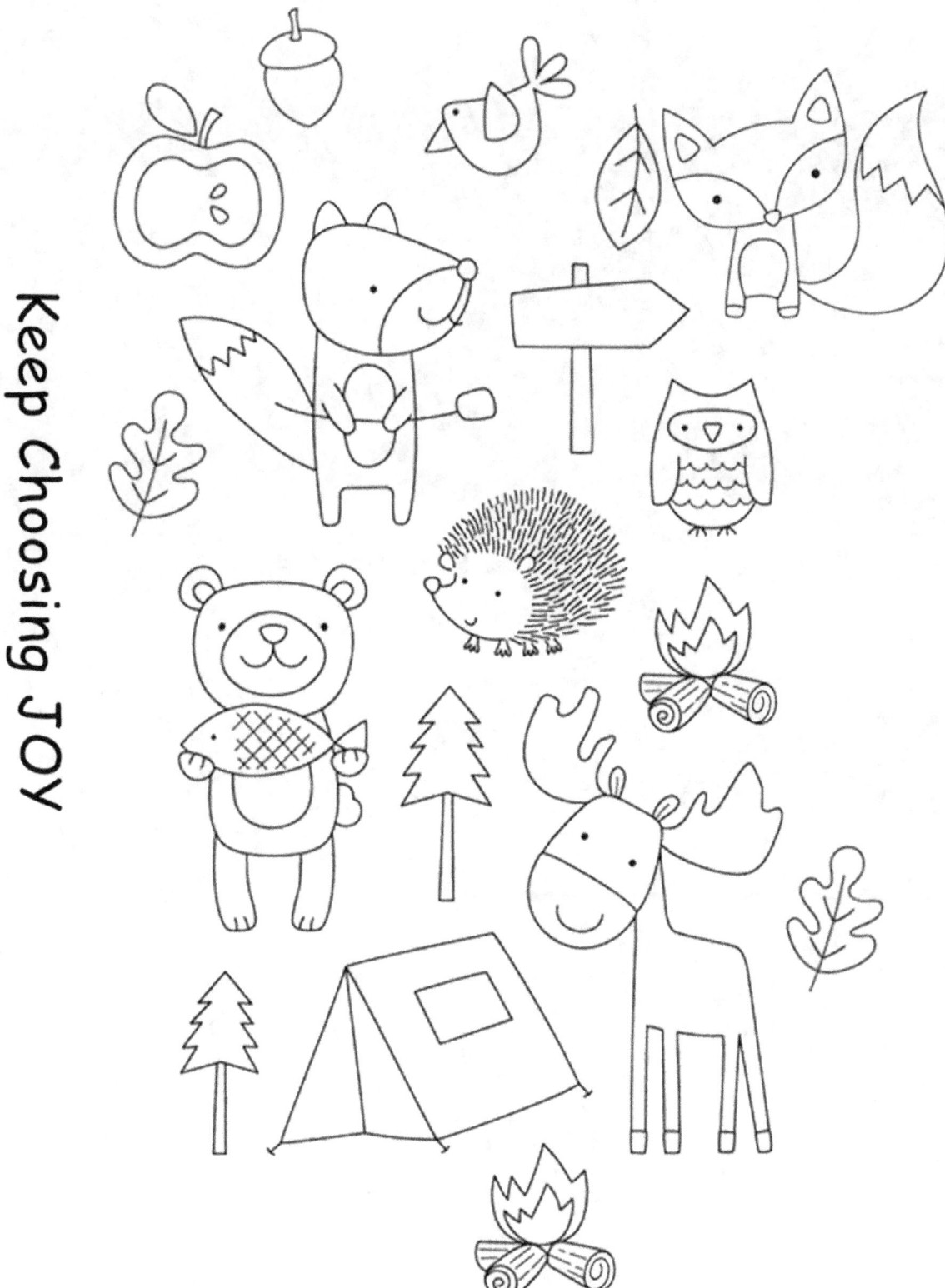

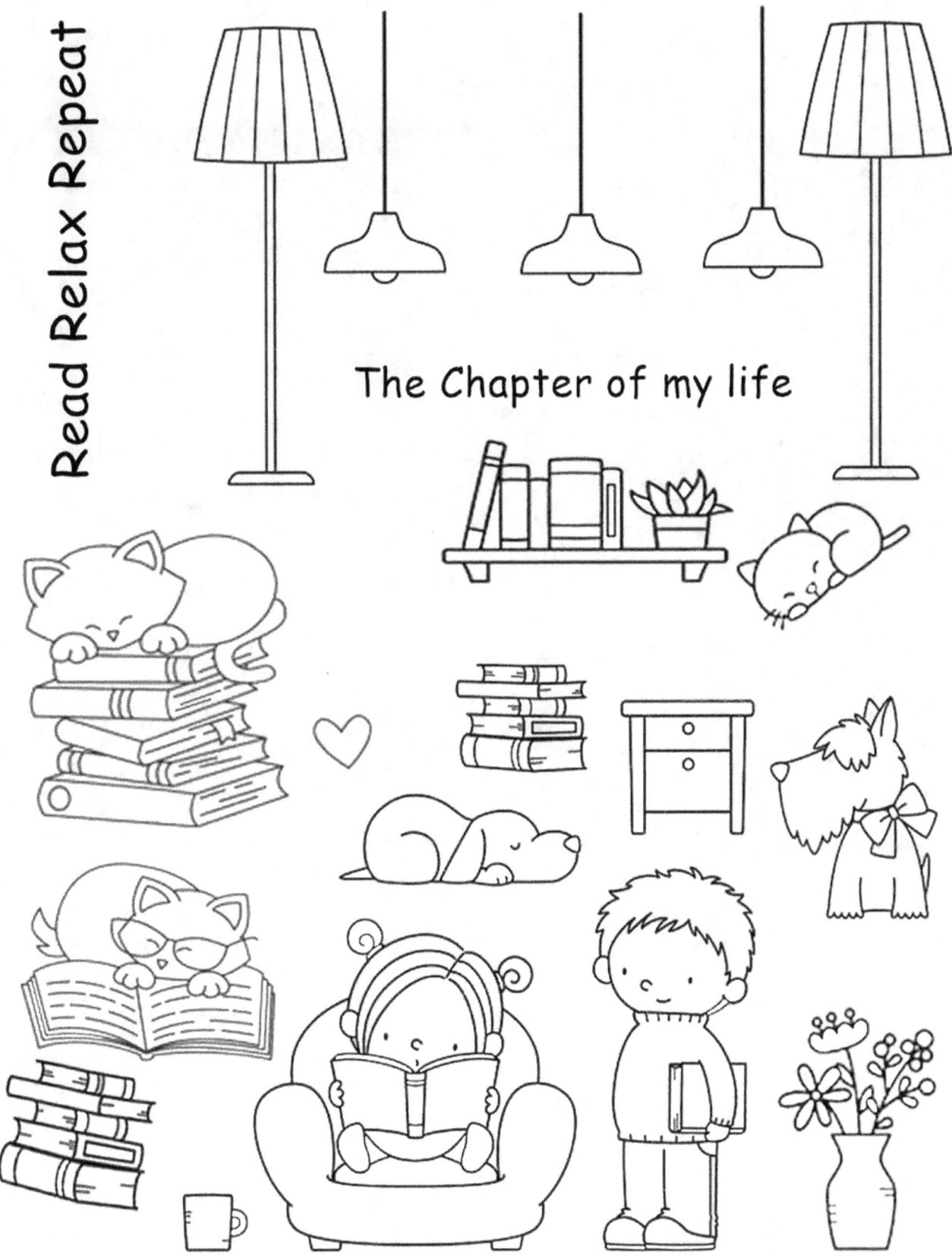

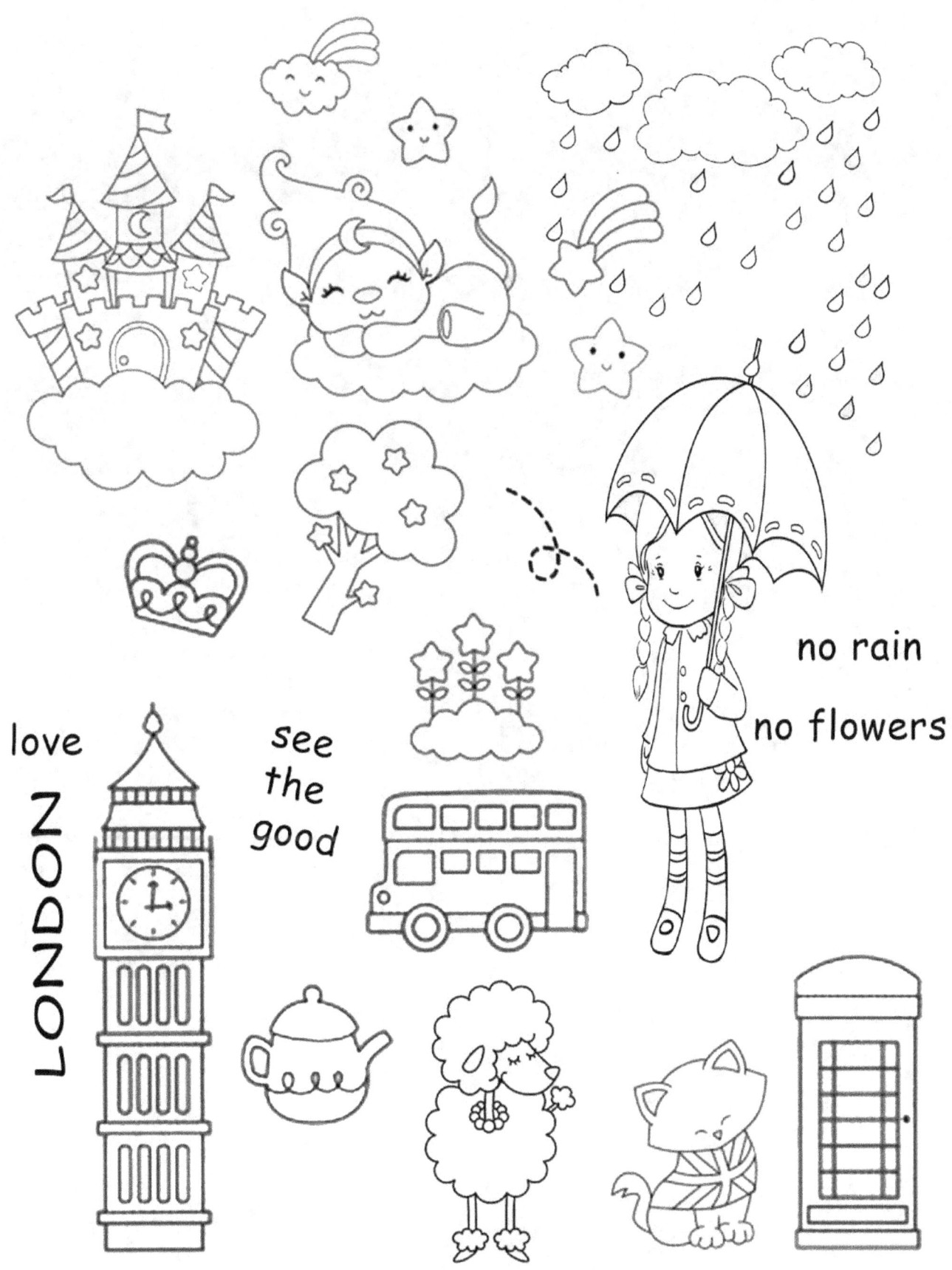

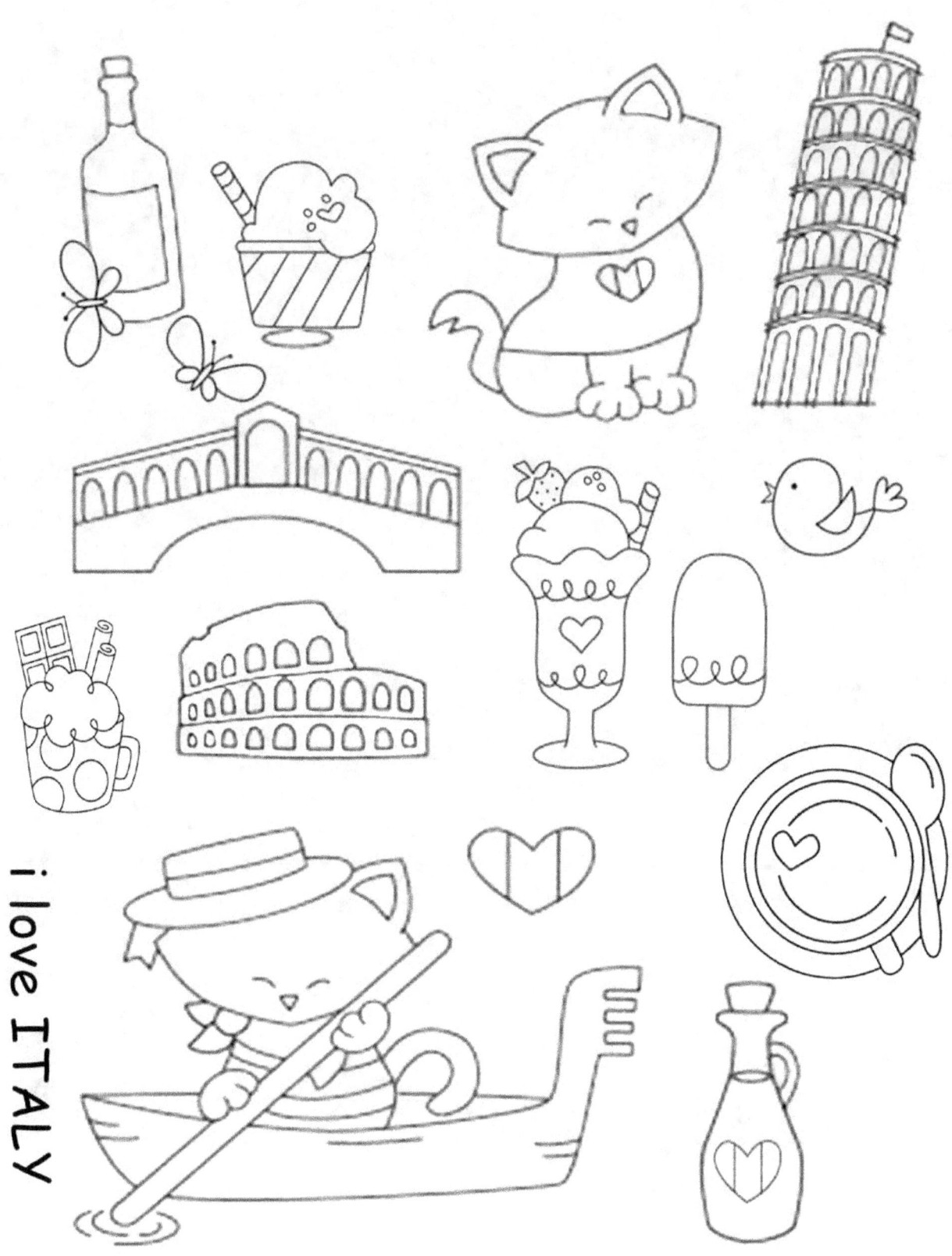

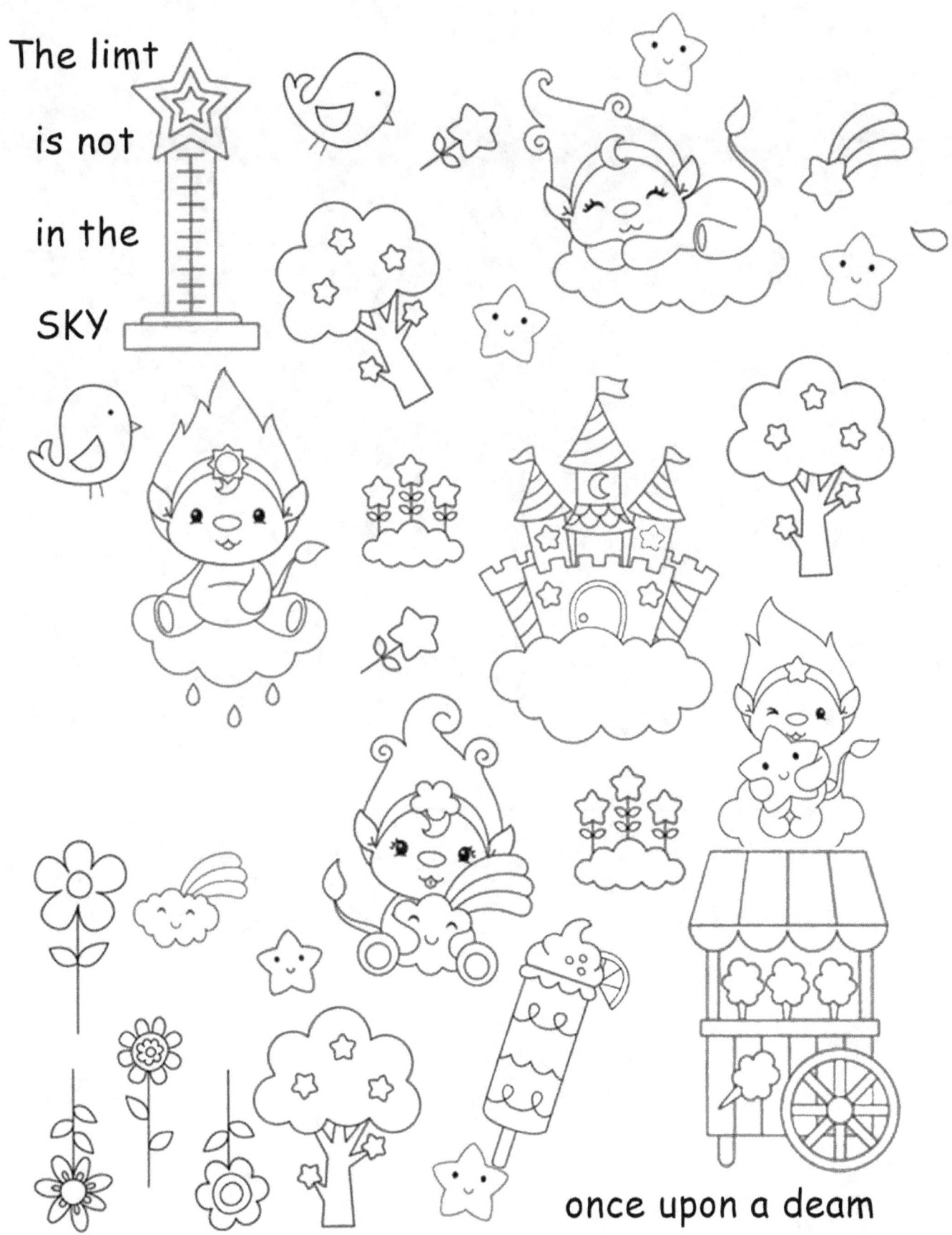

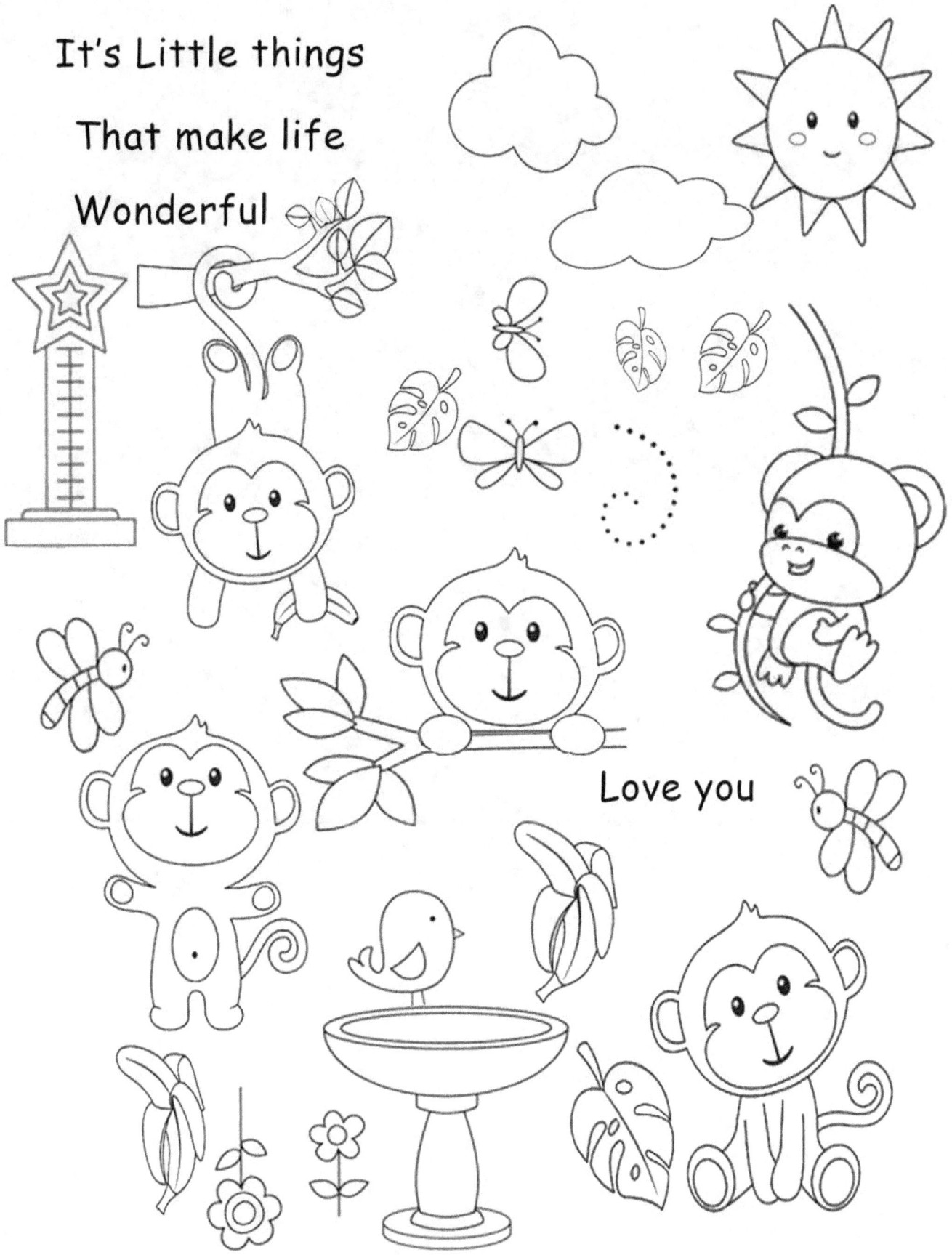

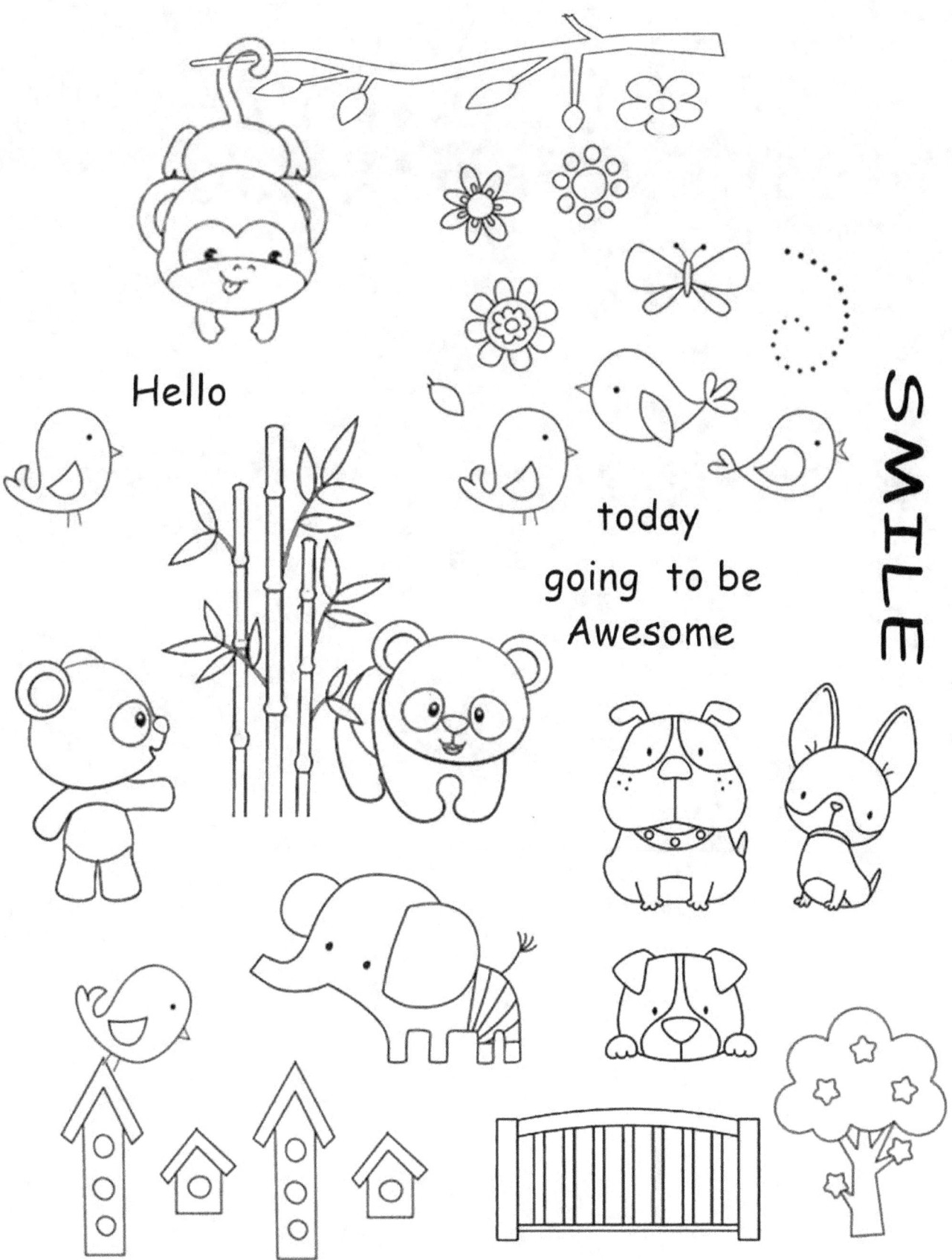

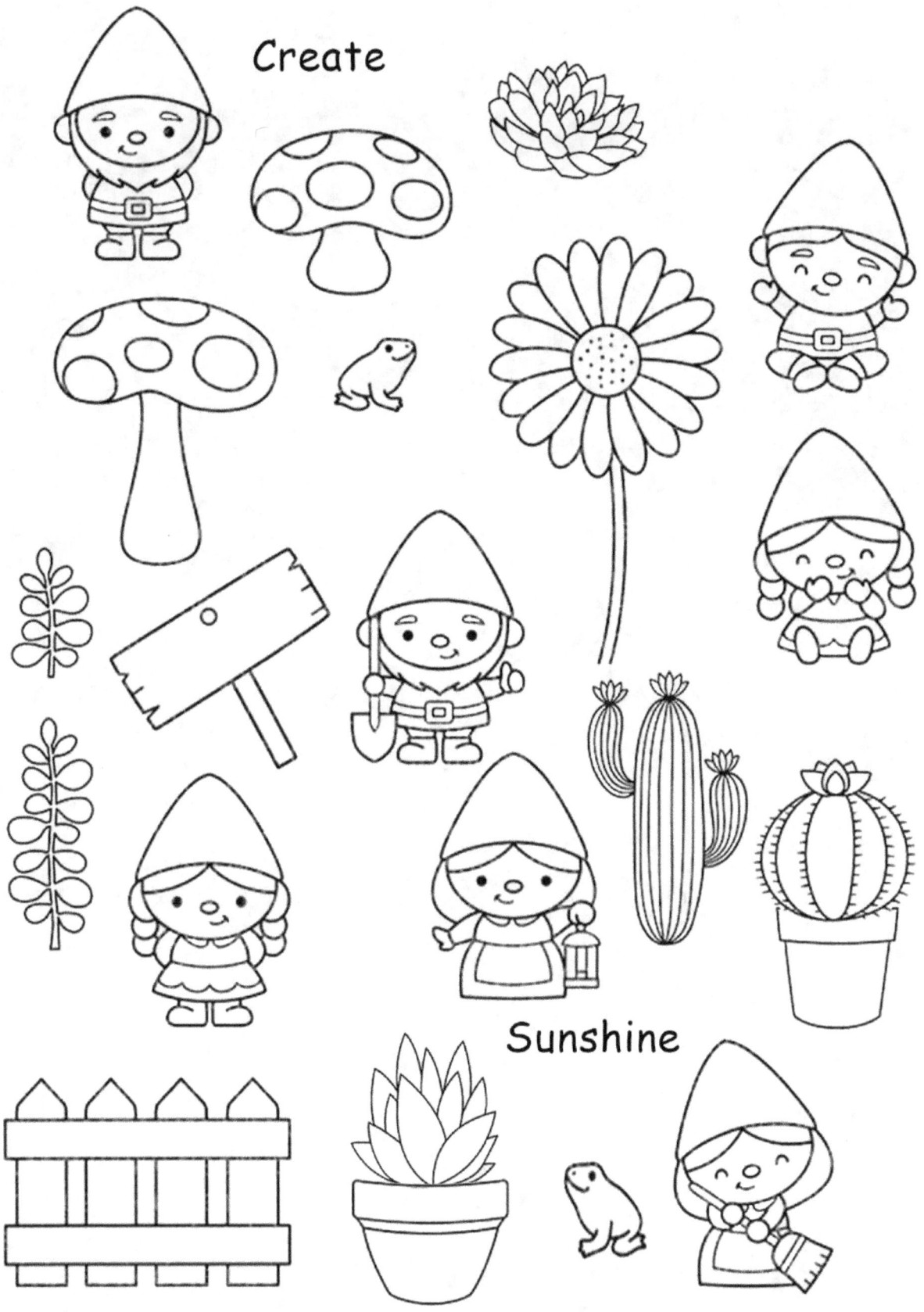

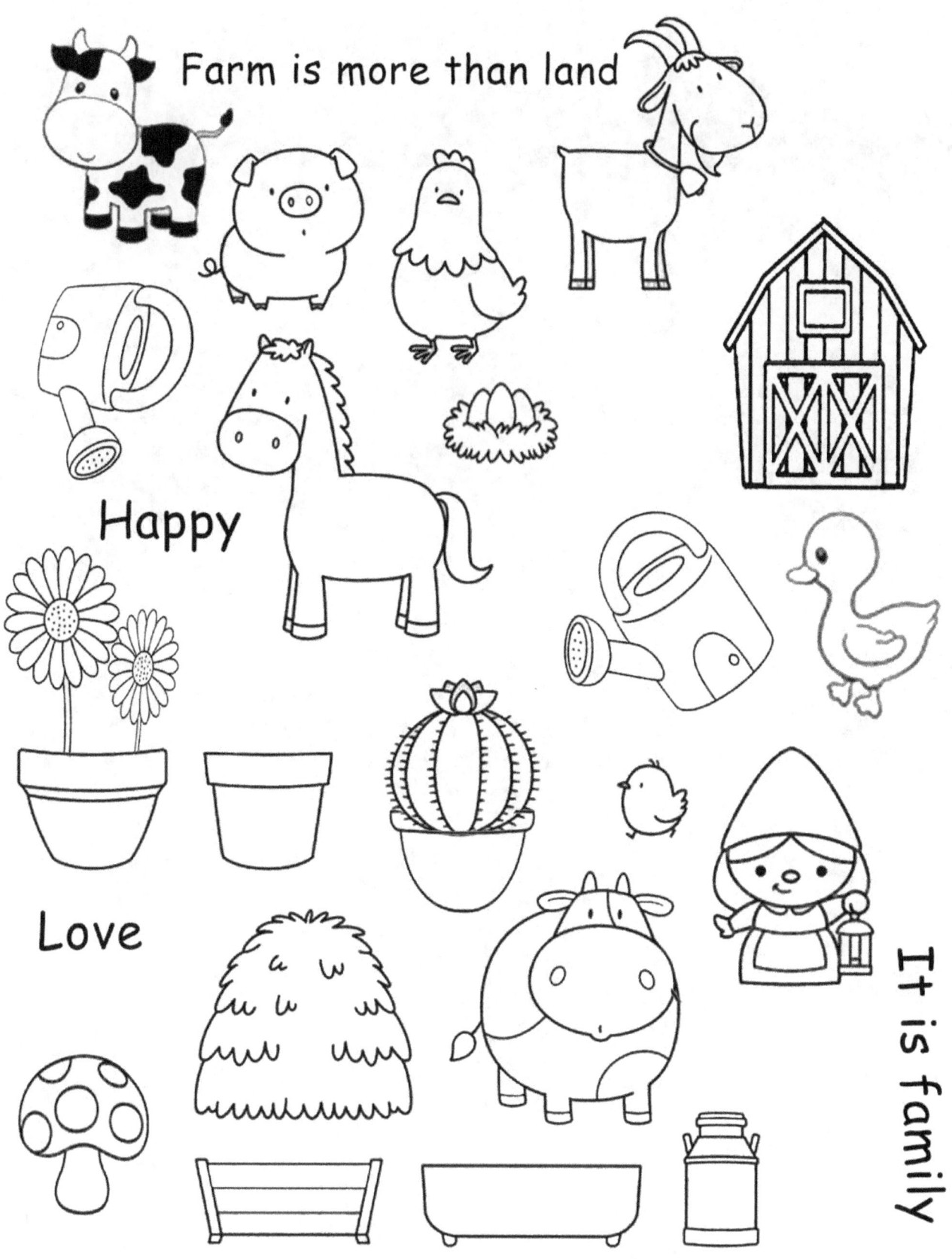

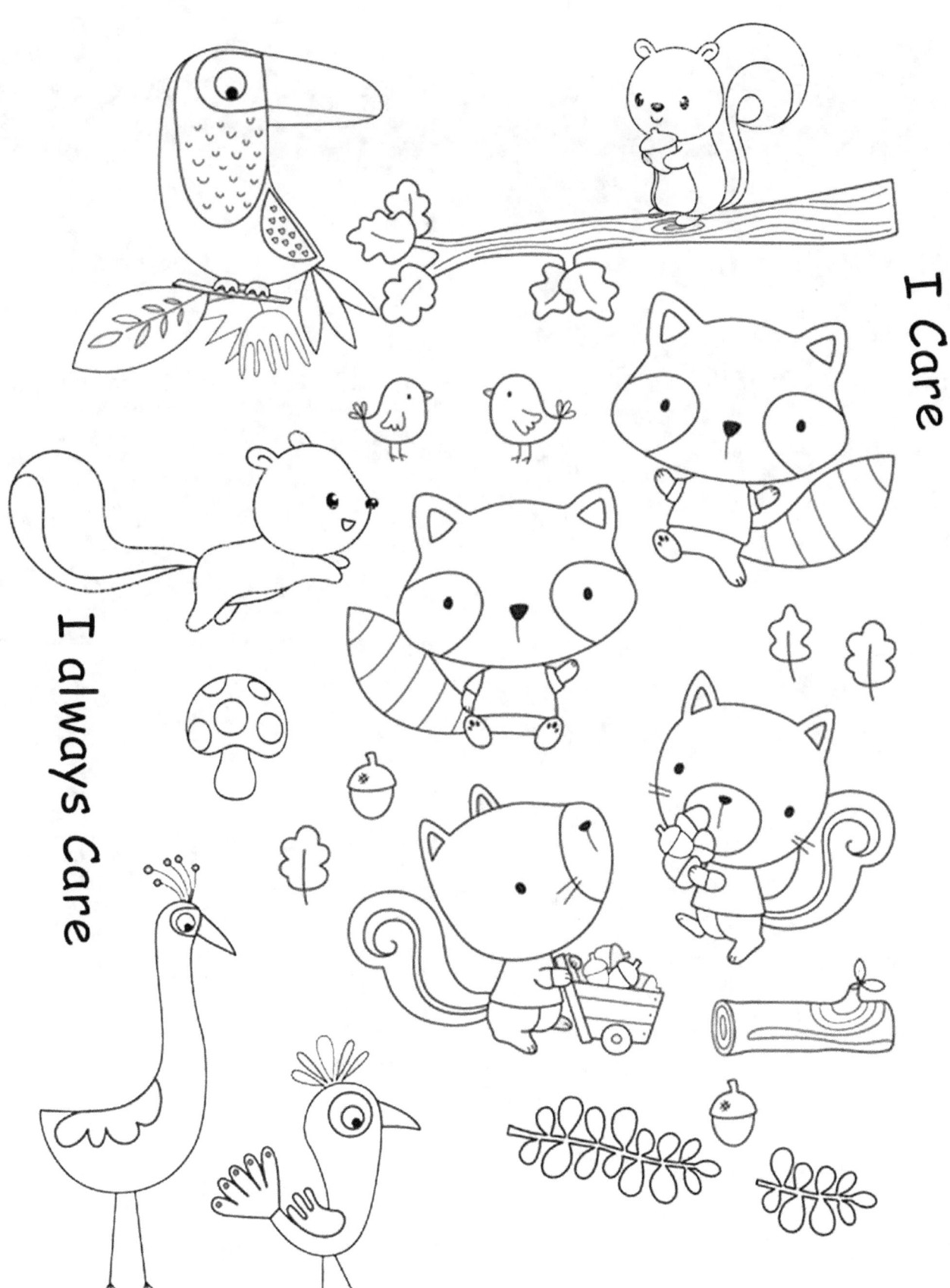

I Care

I always Care

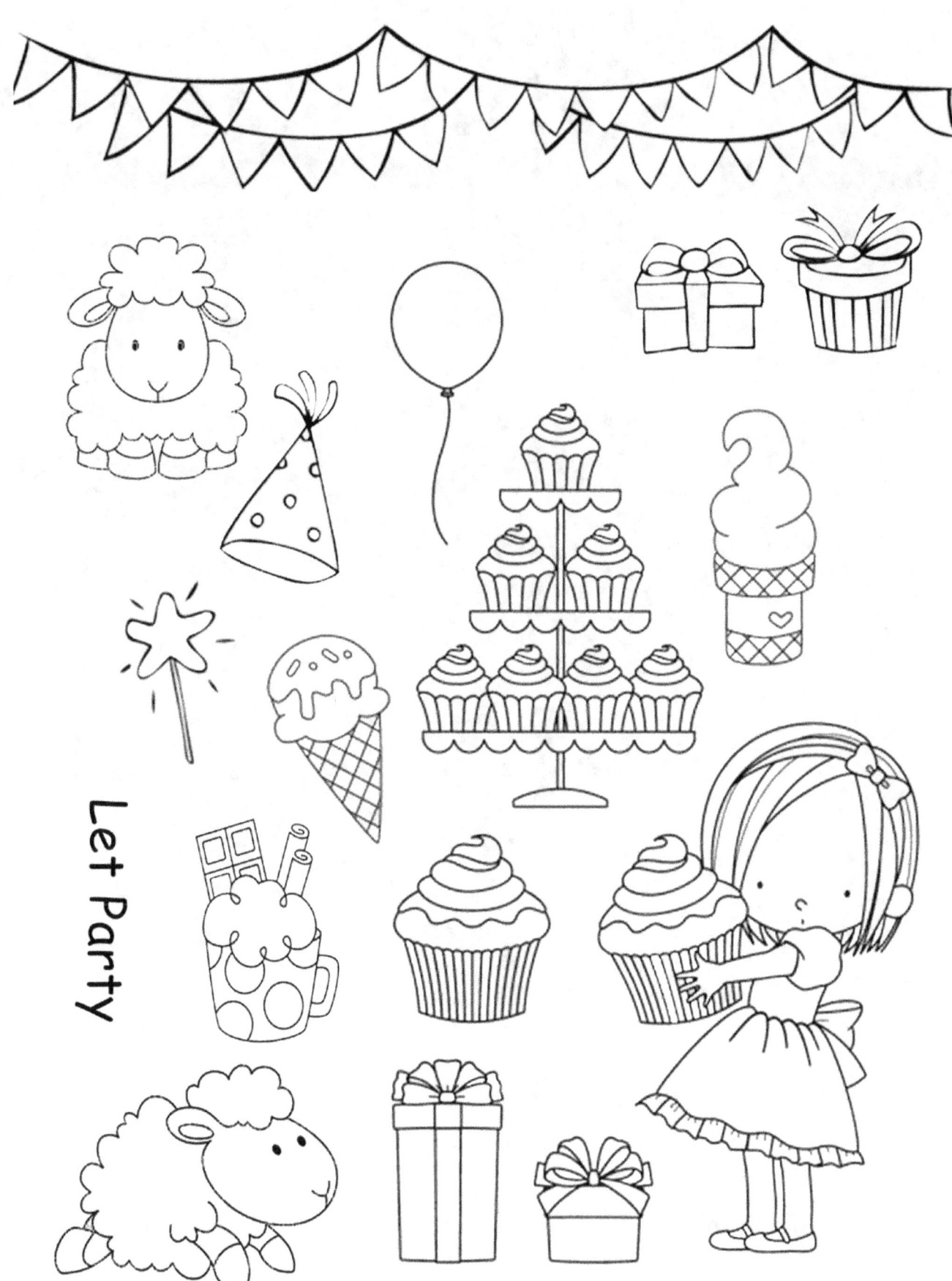

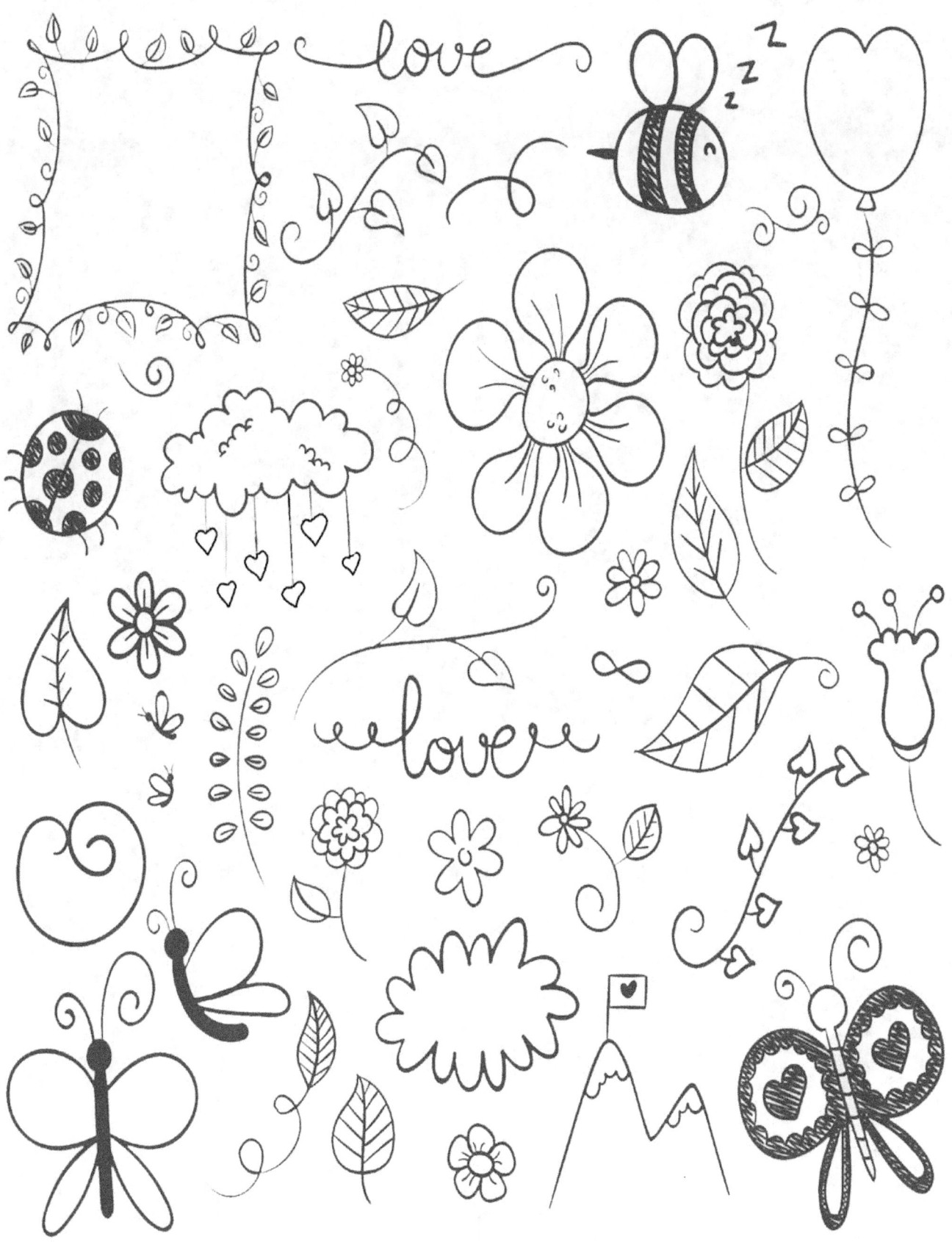

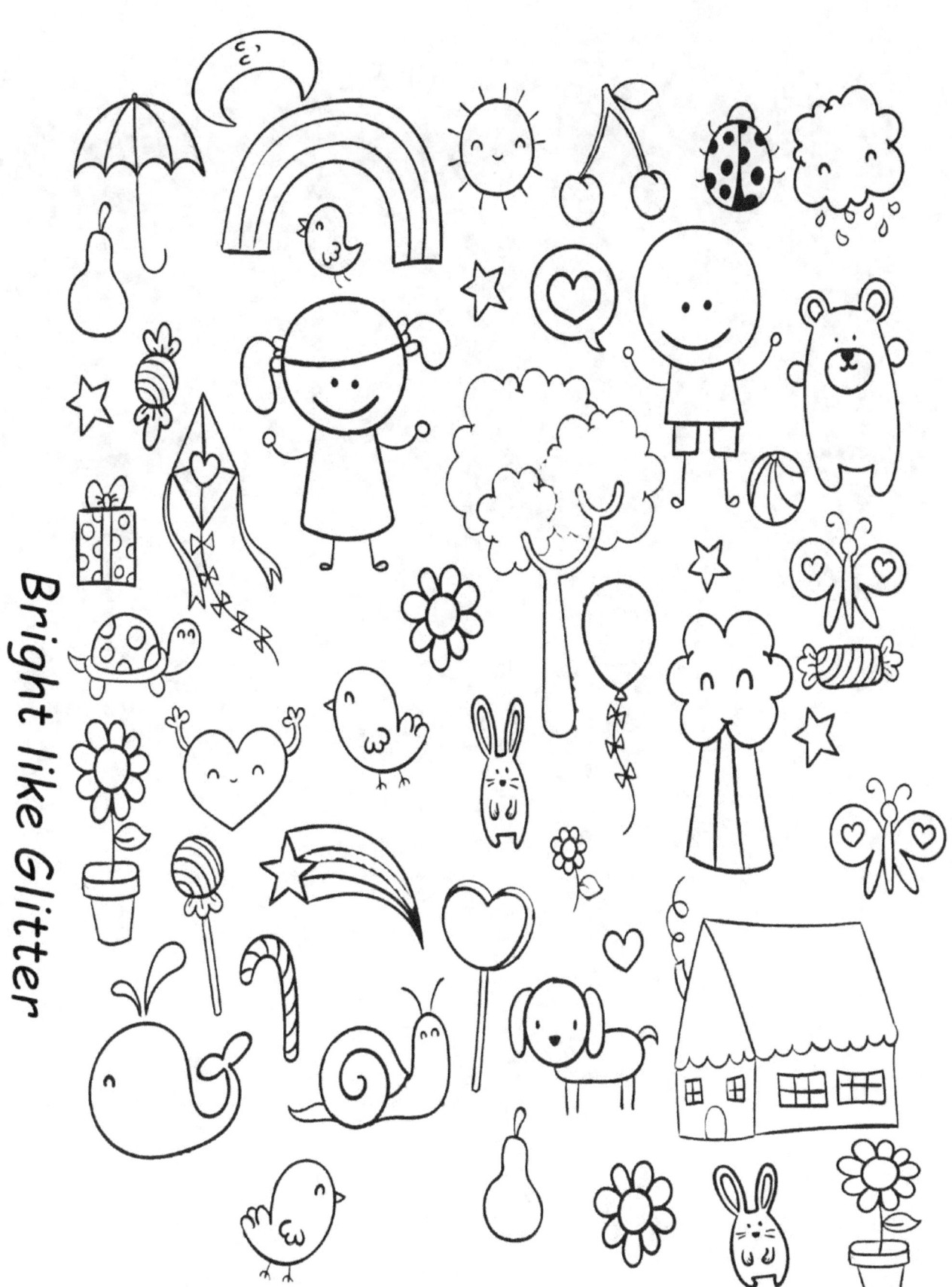

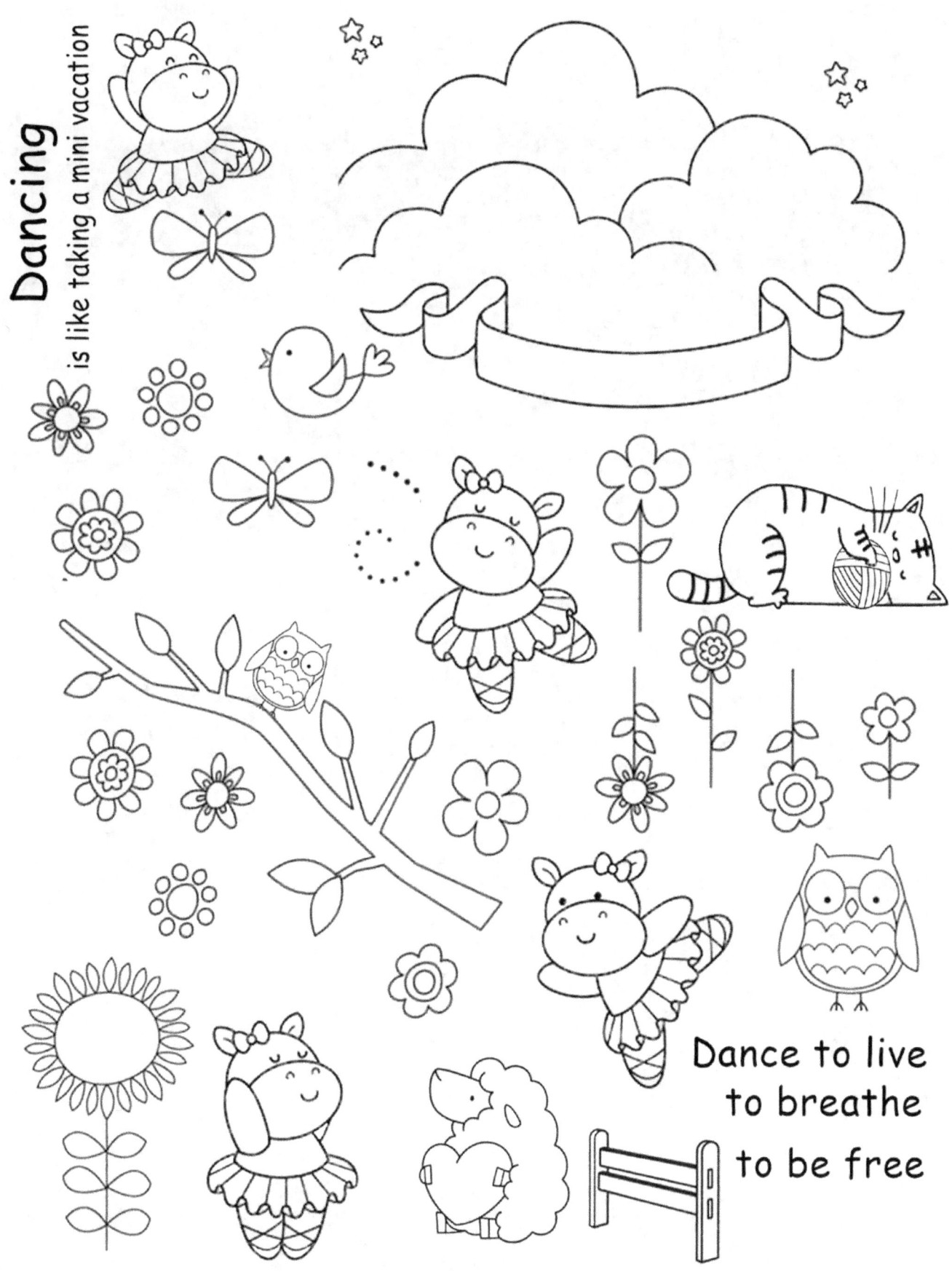

Thank you

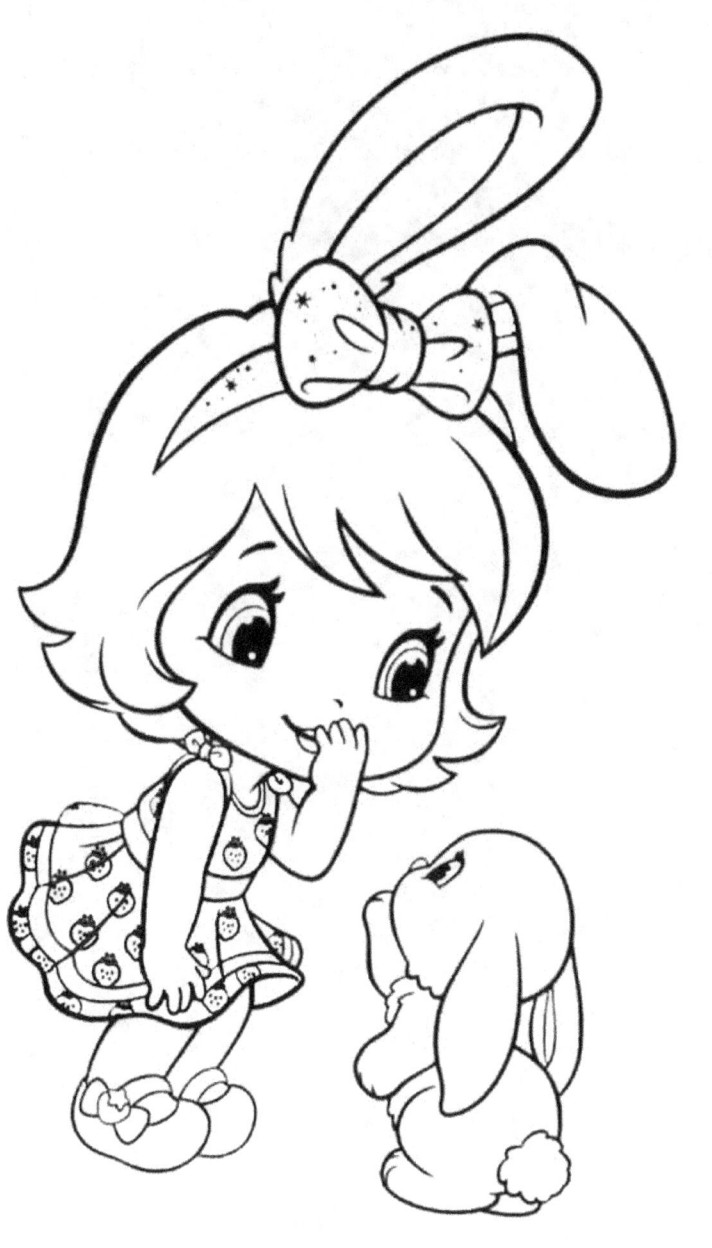